Pug Shots

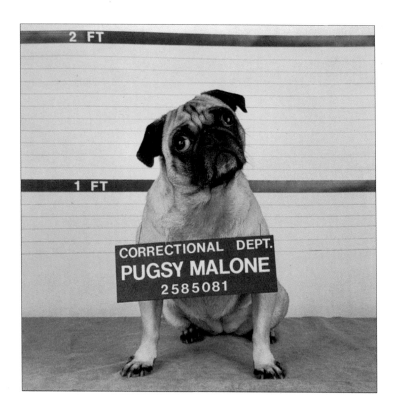
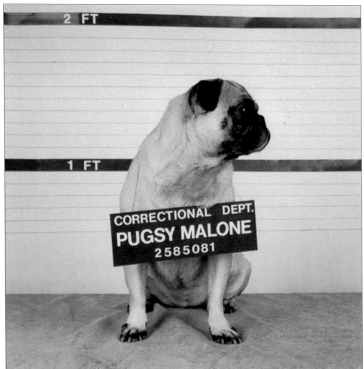

JIM DRATFIELD

Pug Shots

VIKING STUDIO

VIKING STUDIO
Published by the Penguin Group
Penguin Putnam Inc., 375 Hudson Street, New York, New York 10014, U.S.A.
Penguin Books Ltd, 27 Wrights Lane, London W8 5TZ, England
Penguin Books Australia Ltd, Ringwood, Victoria, Australia
Penguin Books Canada Ltd, 10 Alcorn Avenue, Toronto, Ontario, Canada M4V 3B2
Penguin Books (N.Z.) Ltd, 182-190 Wairau Road, Auckland 10, New Zealand

Penguin Books Ltd, Registered Offices:
Harmondsworth, Middlesex, England

First published in 1999 by Viking Studio,
a member of Penguin Putnam Inc.

9 10

Copyright © Jim Dratfield, 1999
All rights reserved

Jim Dratfield's Petography, Inc.™ travels the country doing commissioned
photographic portraiture of pets and pets with their people. For further information:
http://www.petography.com

All photographs are by Jim Dratfield with the exception of the photographs on pp. 32
(Pugcycle), 35 (Pug on the Wagon), and 57 (Pug-Eyed), which are by Jim Dratfield/Paul
Coughlin Petography, Inc.,™ 1995.

Sepia toning courtesy of Sixty-Eight Degrees

Hand tinting courtesy of Al Doggett Studios

ISBN 0-670-88726-9

CIP data available

Printed in U. S. A.
Set in Kennerly
Designed by Francesca Belanger

Without limiting the rights under copyright reserved above, no part of this
publication may be reproduced, stored in or introduced into a retrieval system, or
transmitted, in any form or by any means (electronic, mechanical, photocopying,
recording or otherwise), without the prior written permission of both
the copyright owner and the above publisher of this book.

Pug Shots is dedicated to my mom, Lee Dratfield;

my mentor, Donald Williams; my canine, Caleb Hoover, the "Great Vacuum Dog,"

and to my favorite ice cream, Java Chip,

for each being there when I needed them most.

And finally to all of those wonderful animals, pugged and unpugged,

who bring such joy and comfort into our lives.

"The pug is living proof
that God has a sense of humor."

–Margo Kaufman

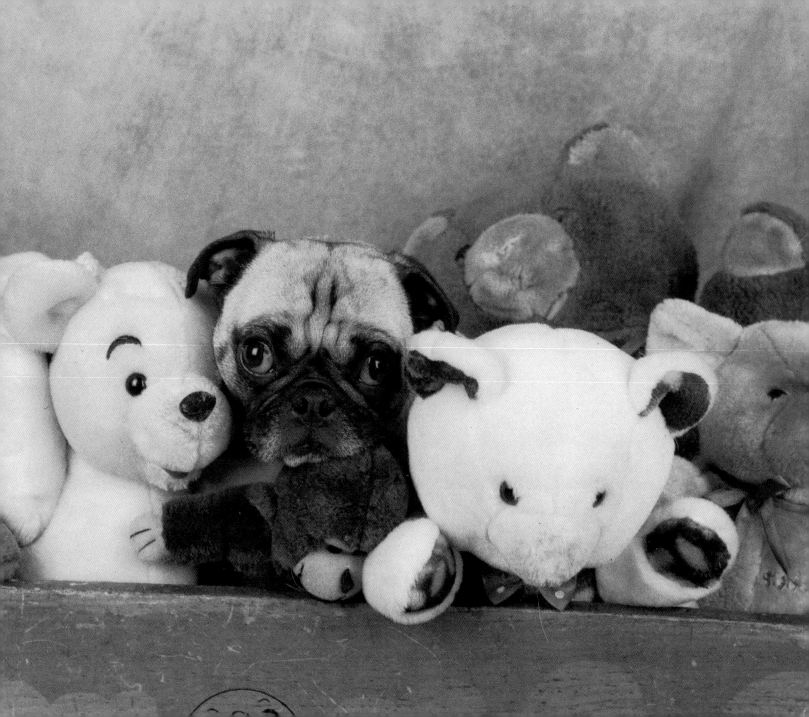

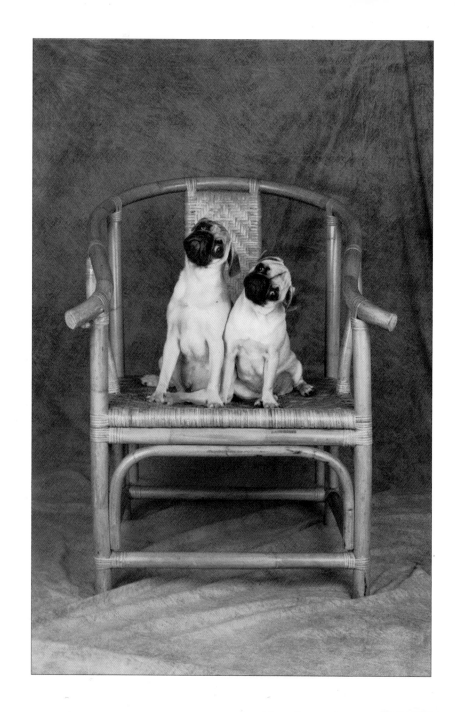

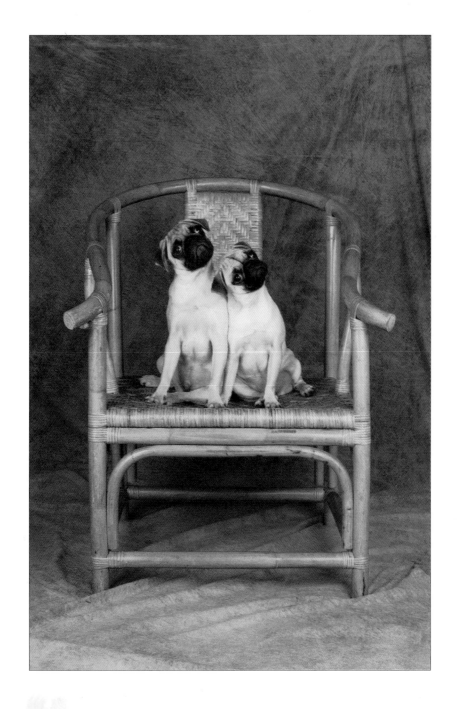

Cabbage Patch Pug

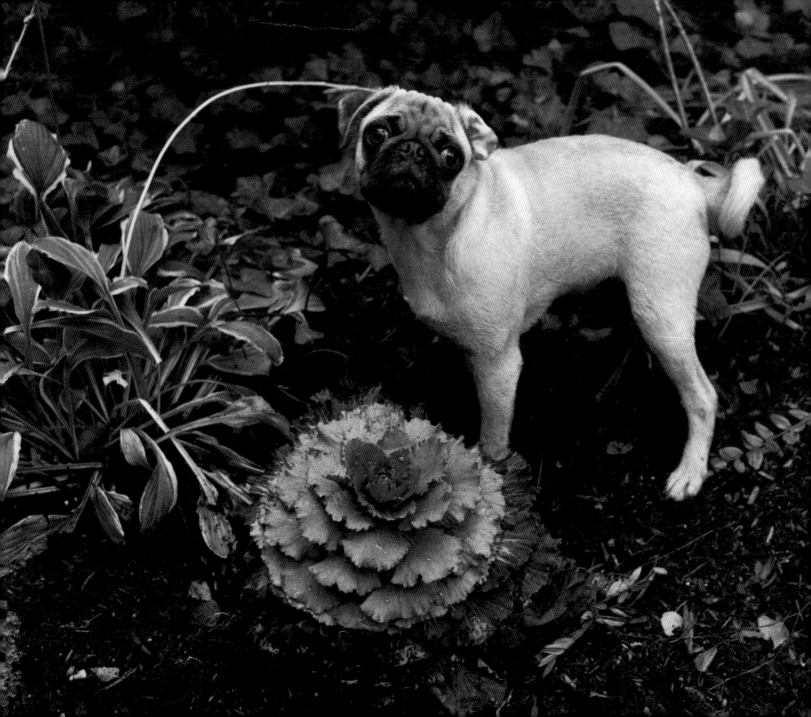

"Oh, what is the matter with
poor Puggy-wug?
Pet him and kiss him
and give him a hug.
Run and fetch him a suitable drug.
Wrap him up tenderly all in a rug.
That is the way to cure Puggy-wug."

–Winston Churchill

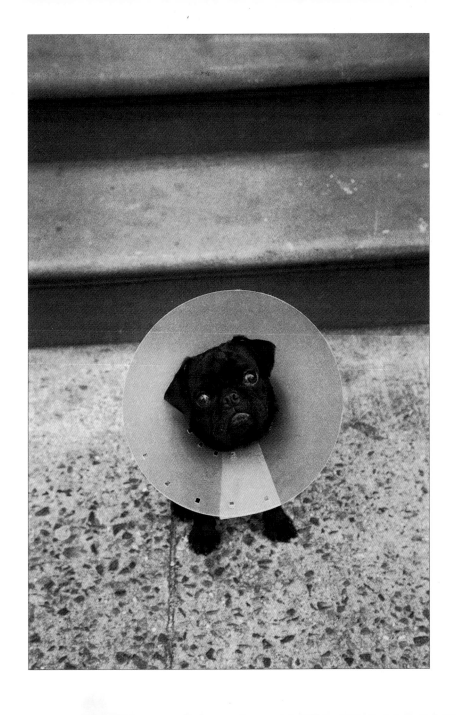

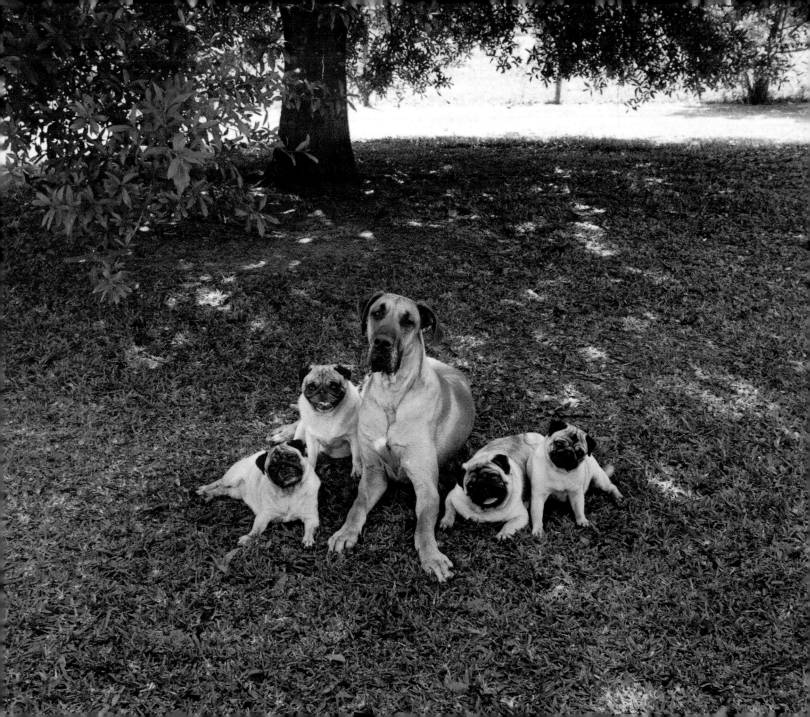

PUG ENVY

PUGNACIOUS

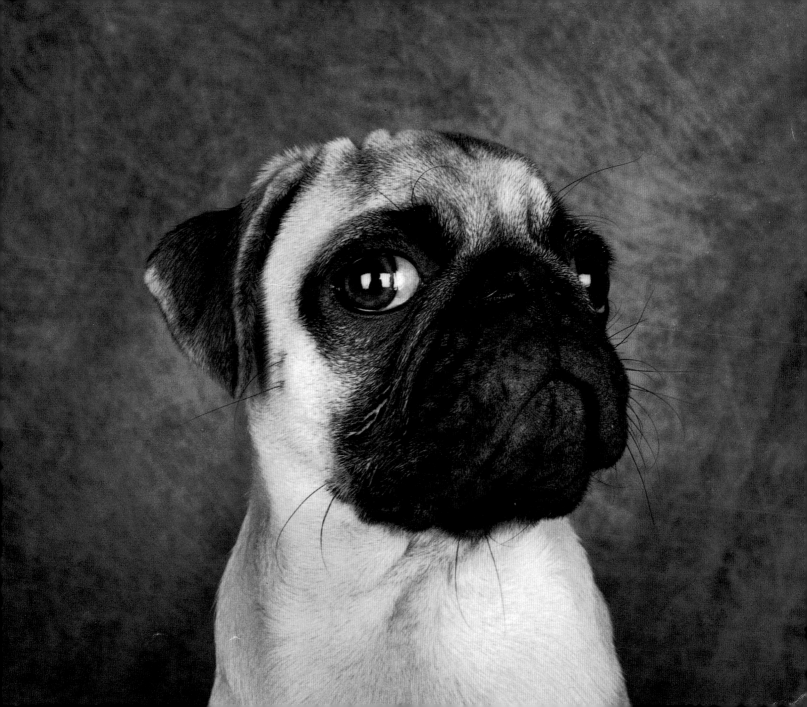

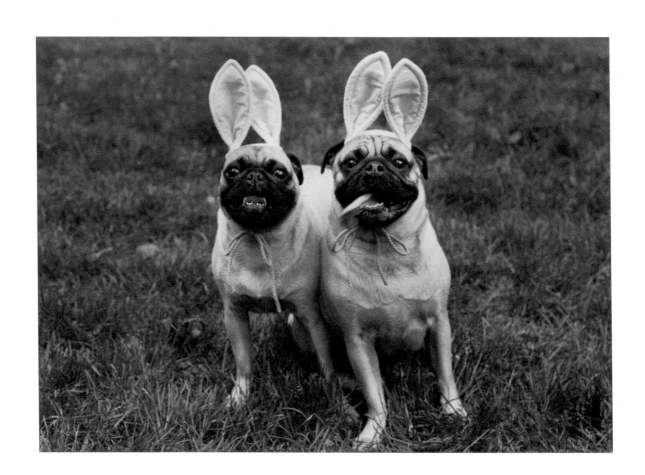

Pugs Bunny

DUNE PUGGY

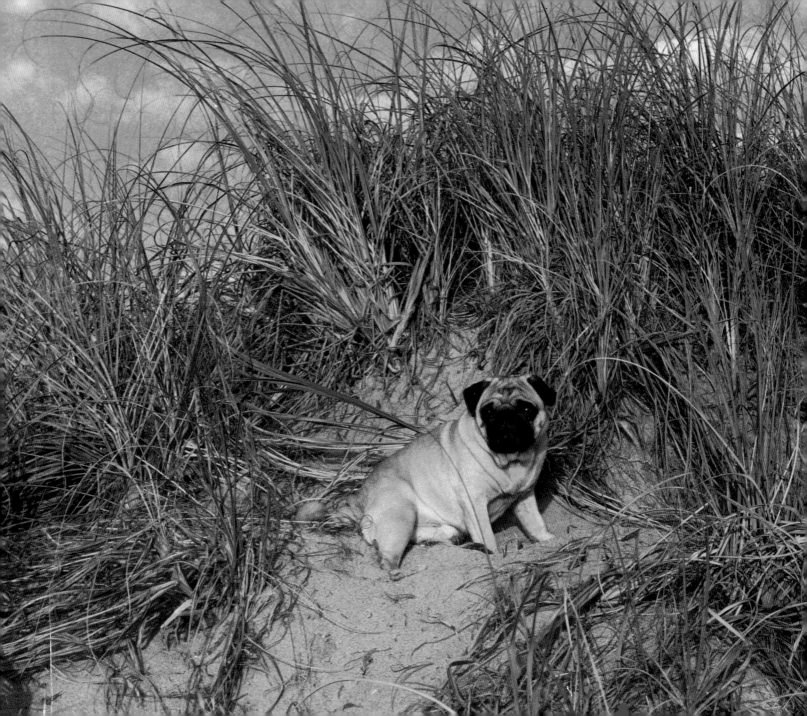

Litter Pugs

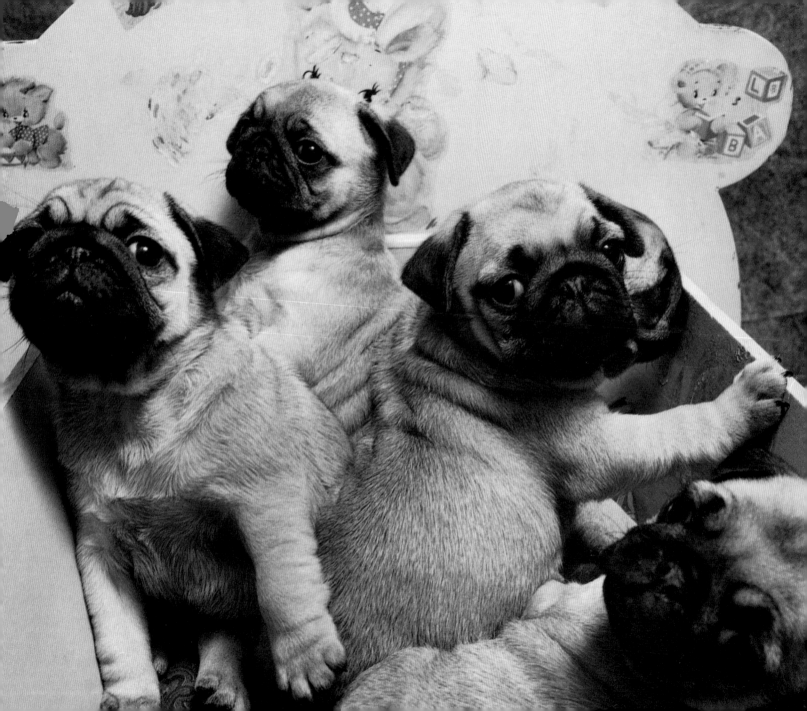

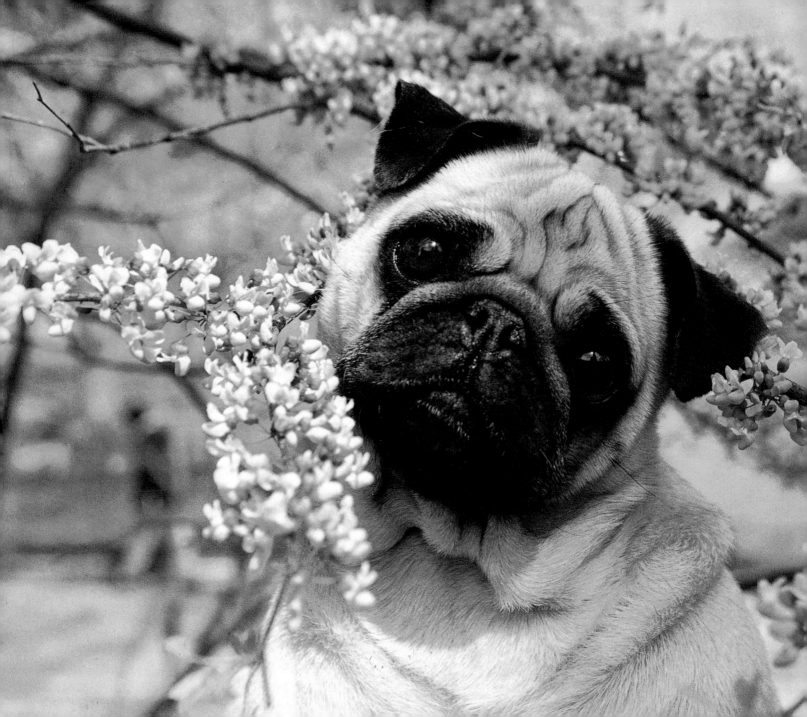

"A veritable pug of pugs, with large soft loving eyes."

–*The World*, 1876

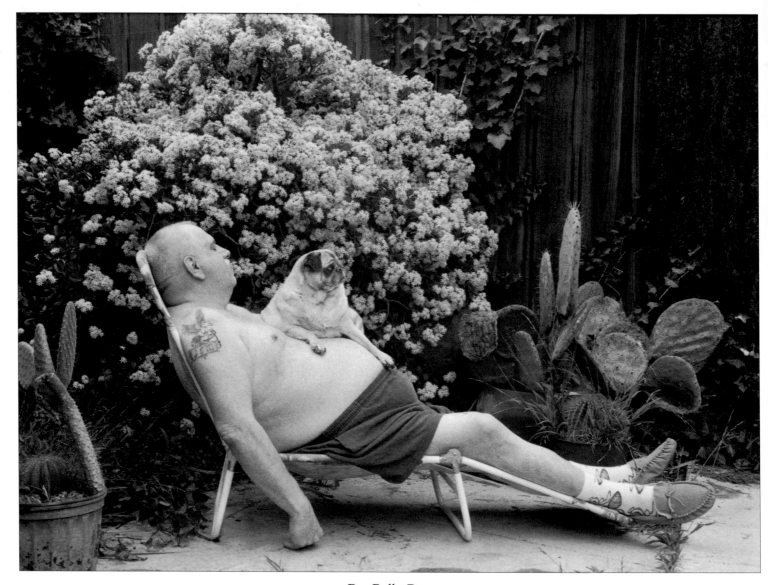

Pot Belly Pug

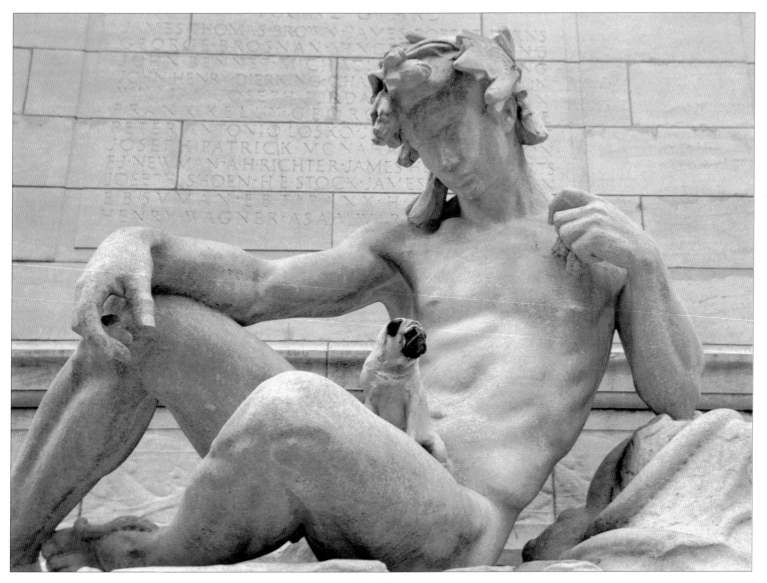

Lap Dog

Pug o' My Heart

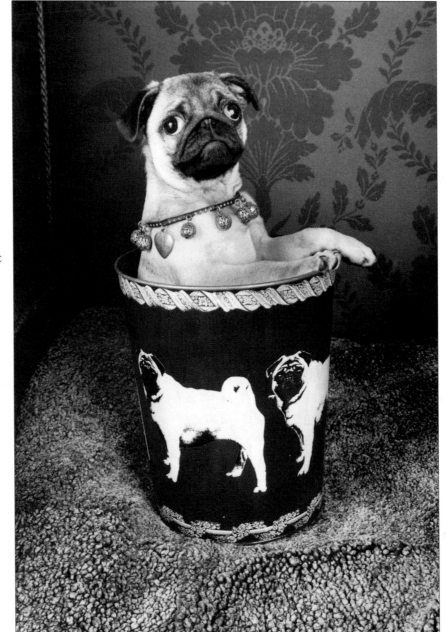

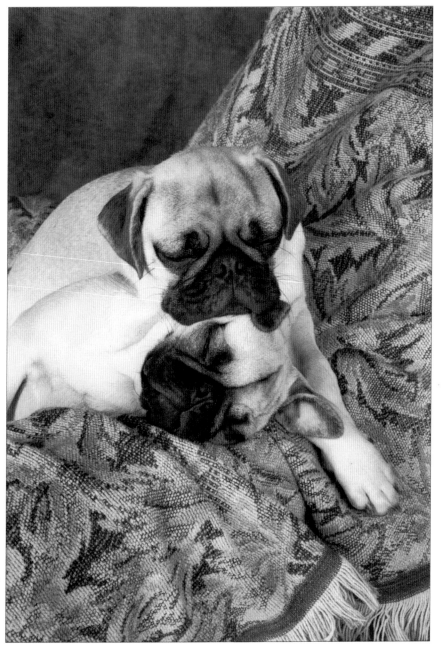

Hush Puggies

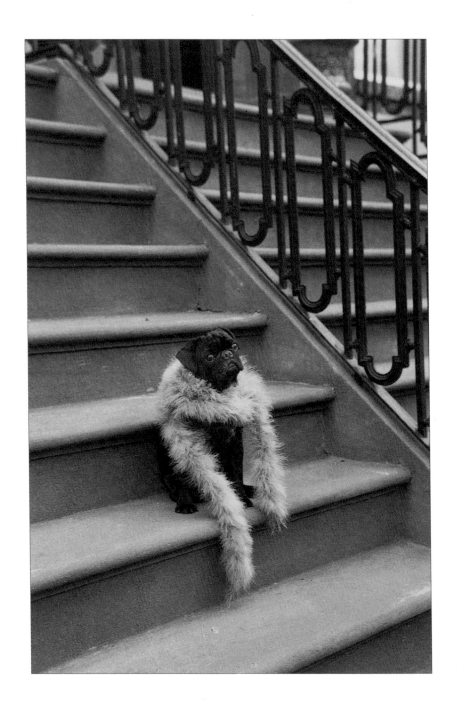

Lady Pugs

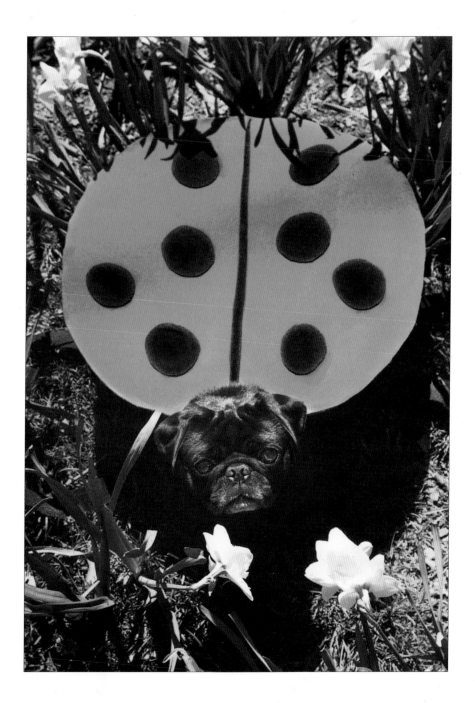

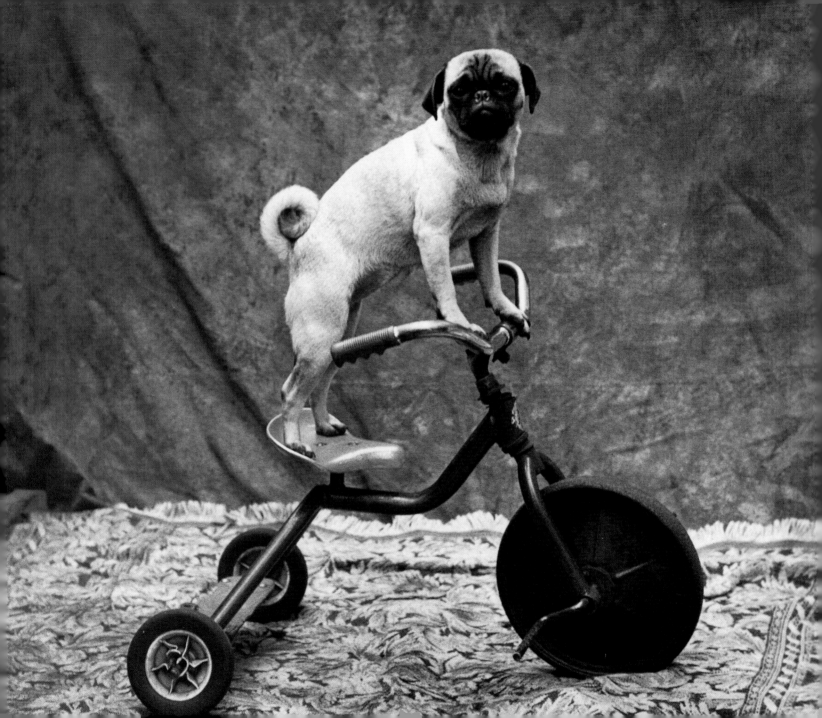

Pugcycle

Lush Puppy

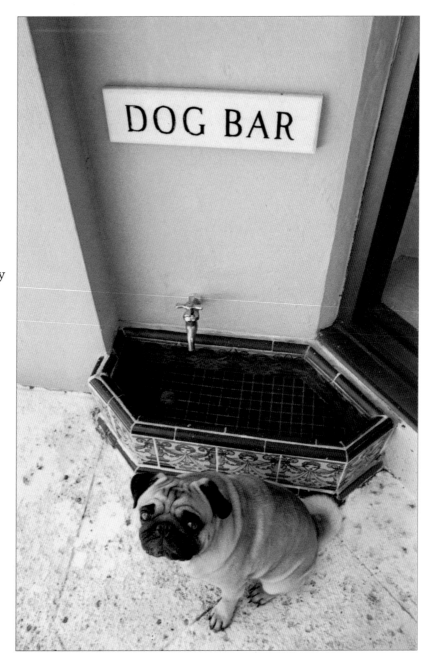

Pug on the Wagon

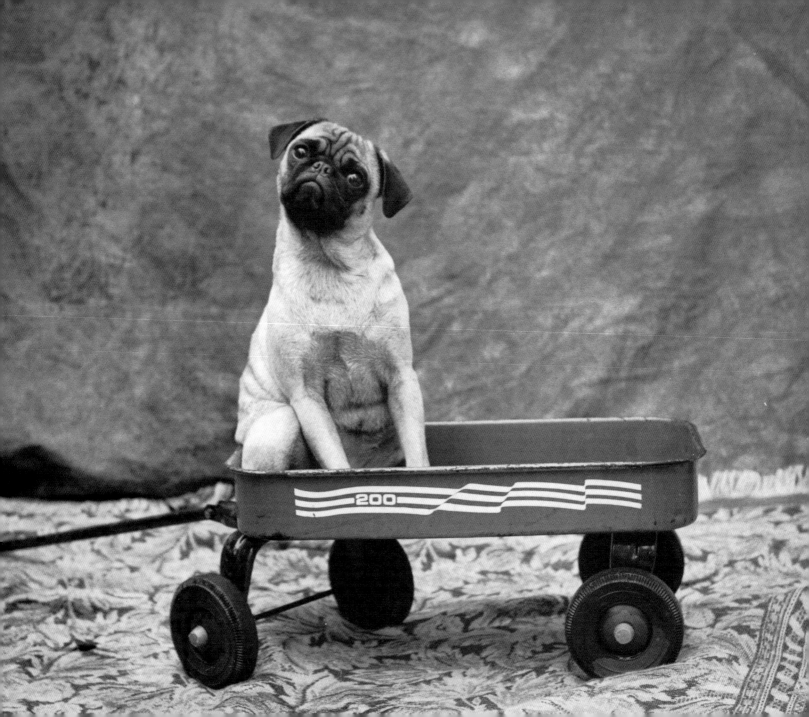

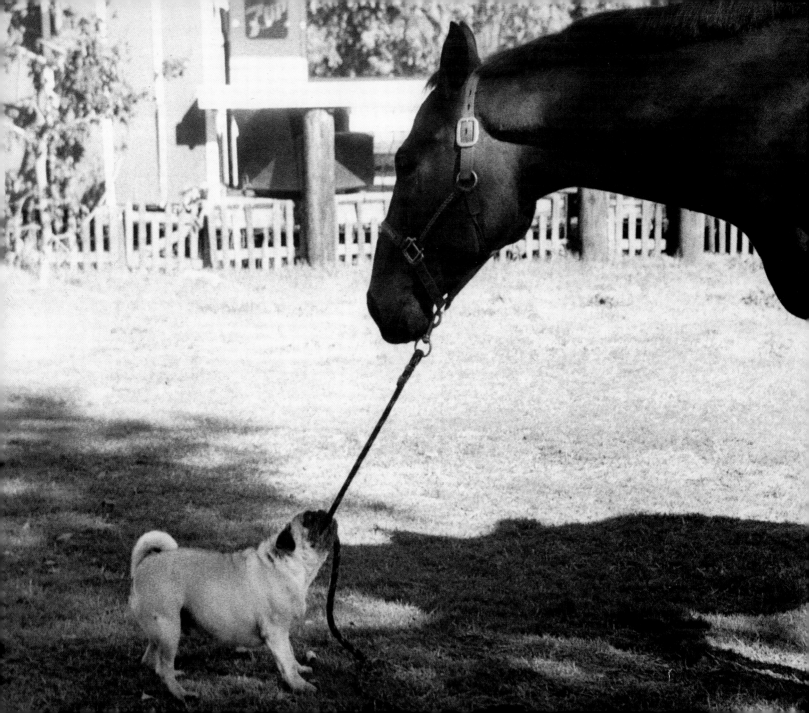

HORSE AND PUGGY

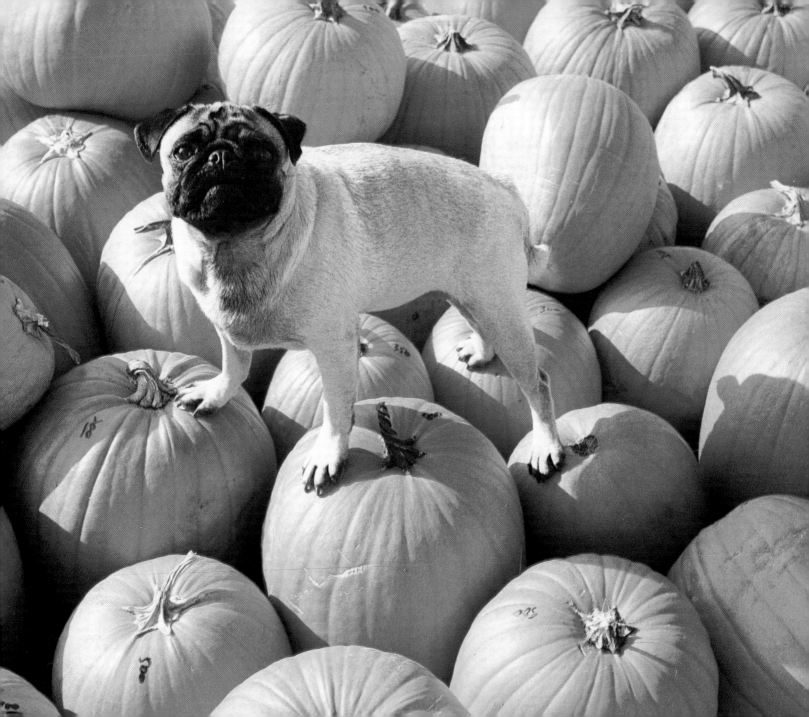

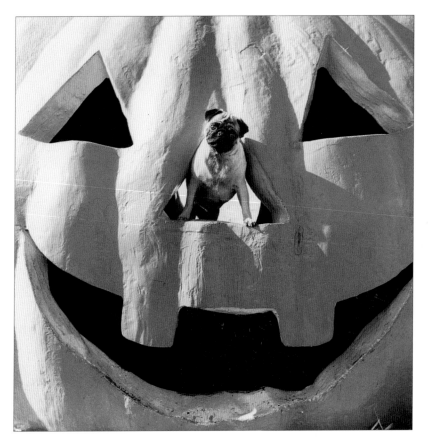

Pug o' Lantern

Pug in a Rug

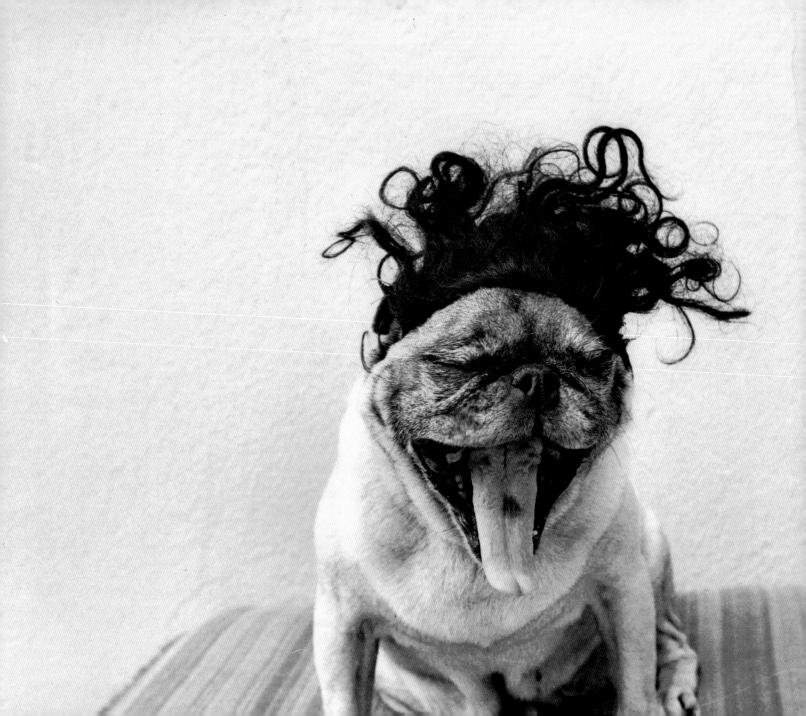

Three Pugs
in a
Fountain

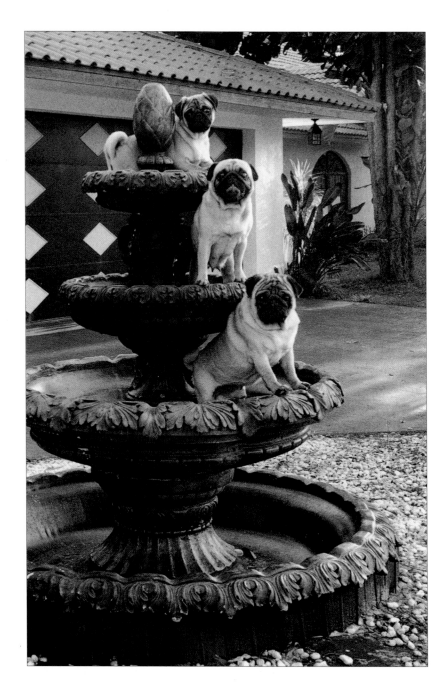

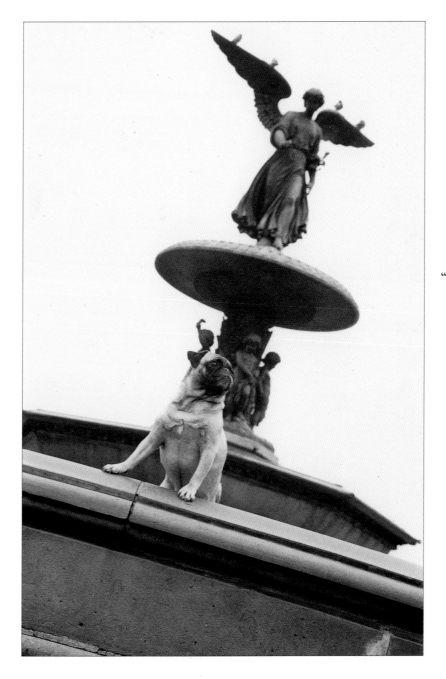

"You think dogs will not
be in heaven?
I tell you, they will be
there long before
any of us."

–Robert Louis Stevenson

STRAWBERRY FIELDS FOREVER

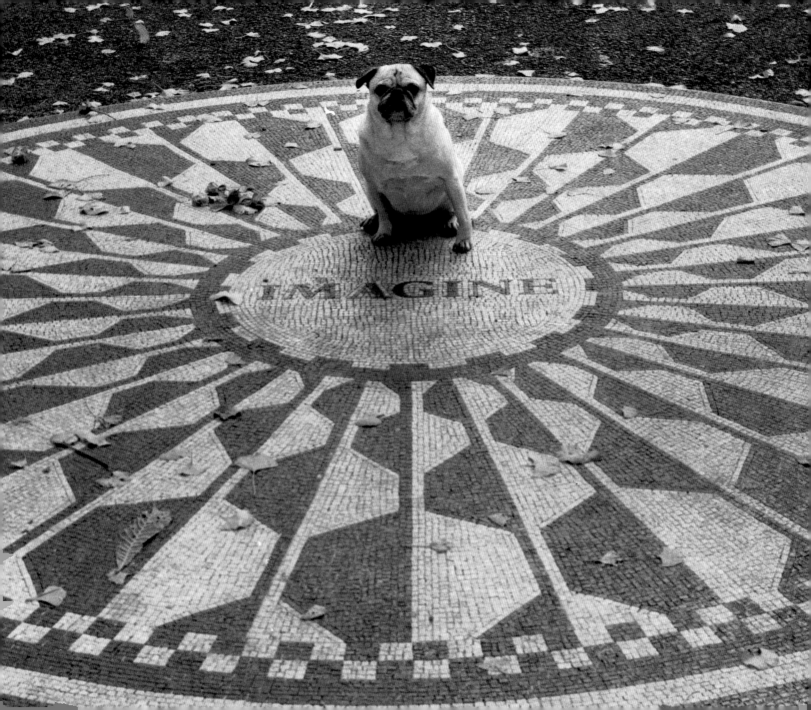

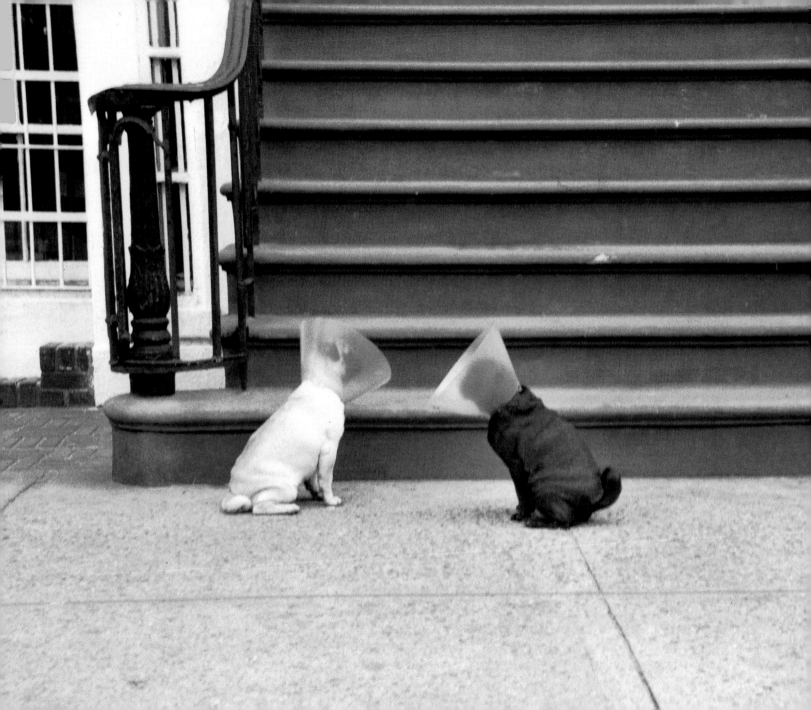

Greetings

PUGZ 'N THE HOOD

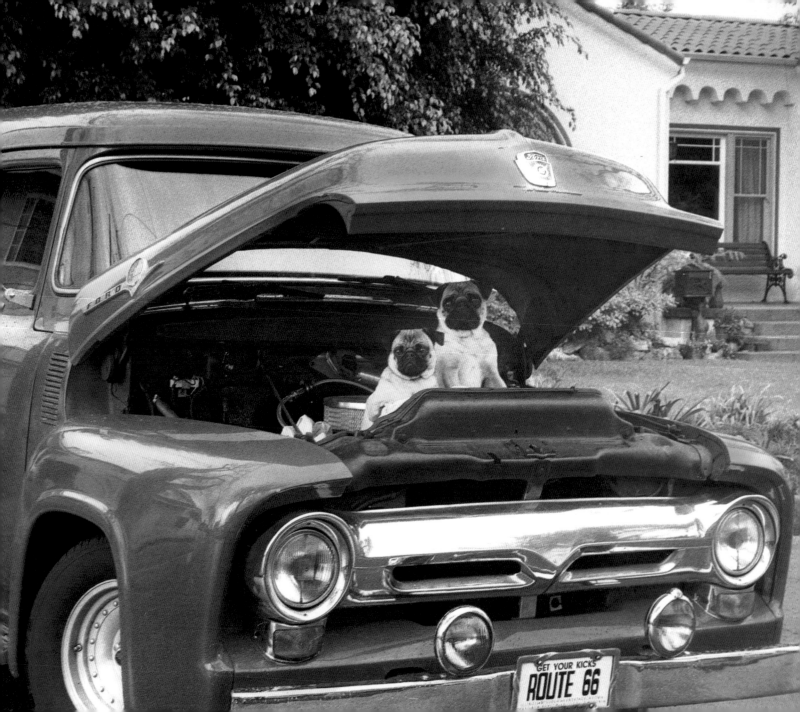

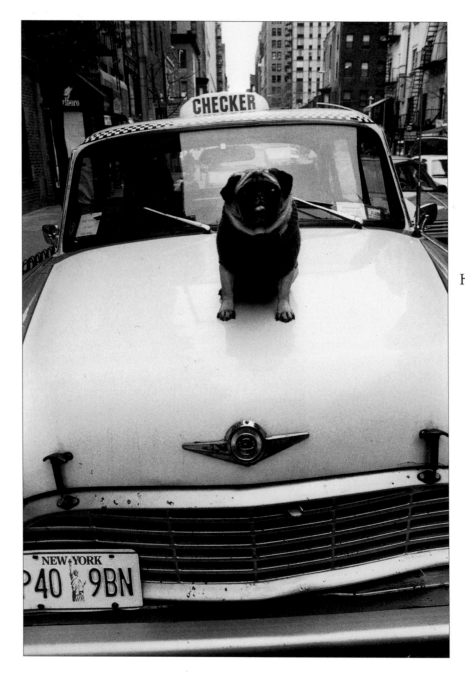

Hood Ornament

Pug in a Bug

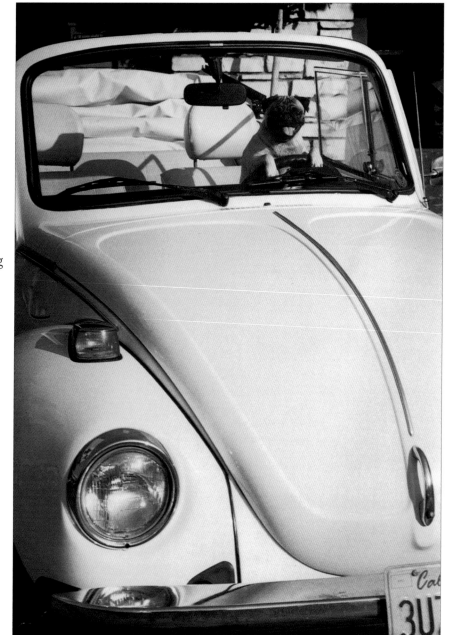

Bird-watching

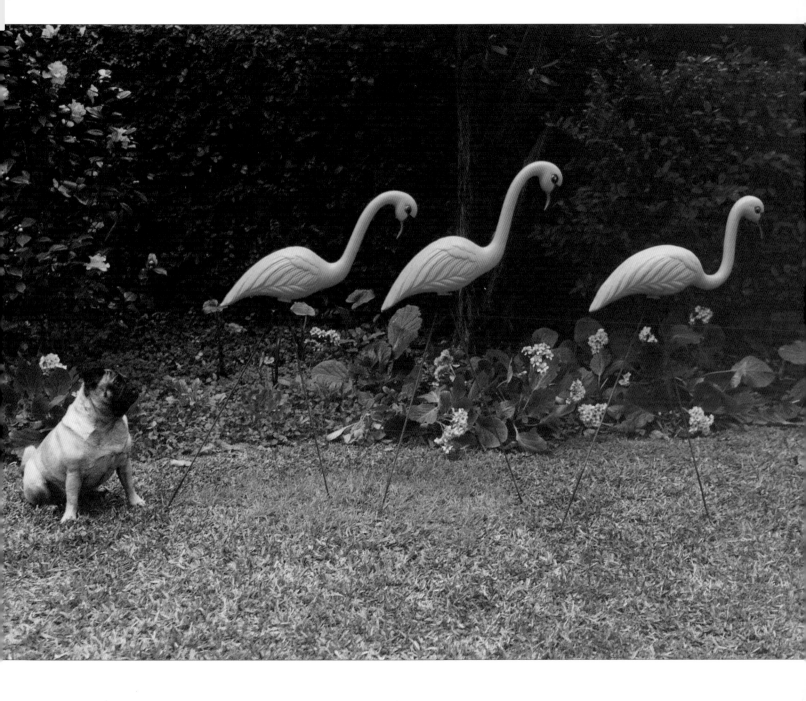

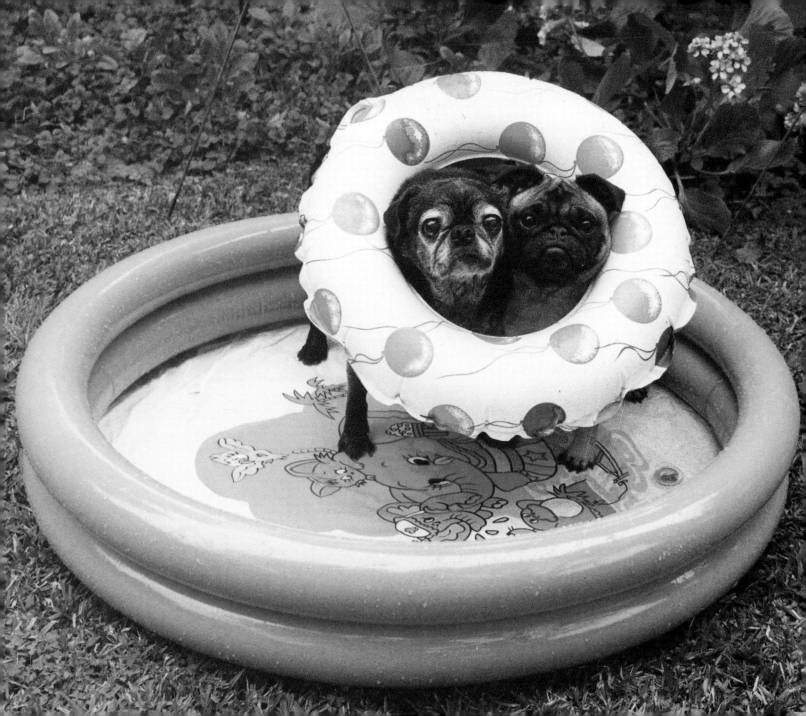

Water Pugs

Rub-a-dub Pug

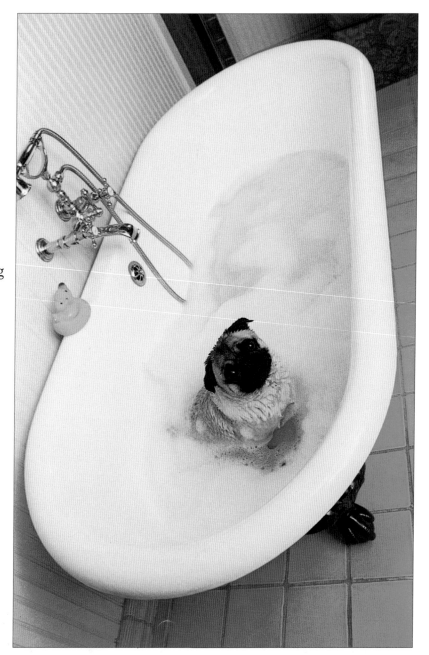

Pug-Eyed

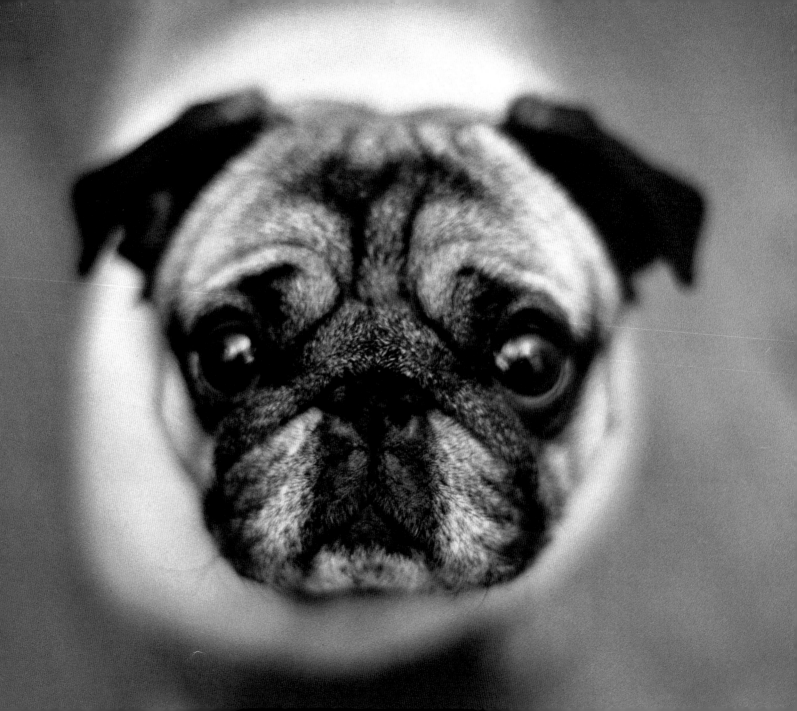

U.S. Mail Pug

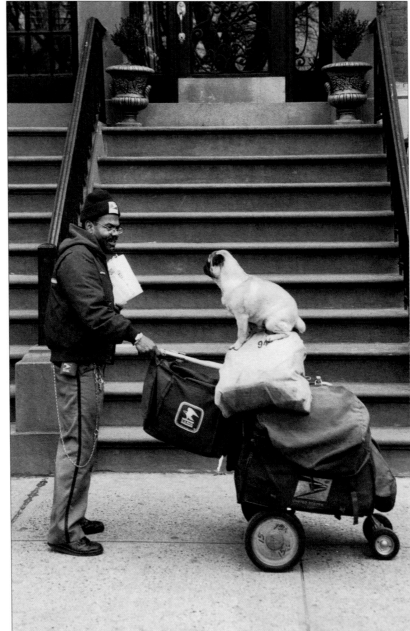

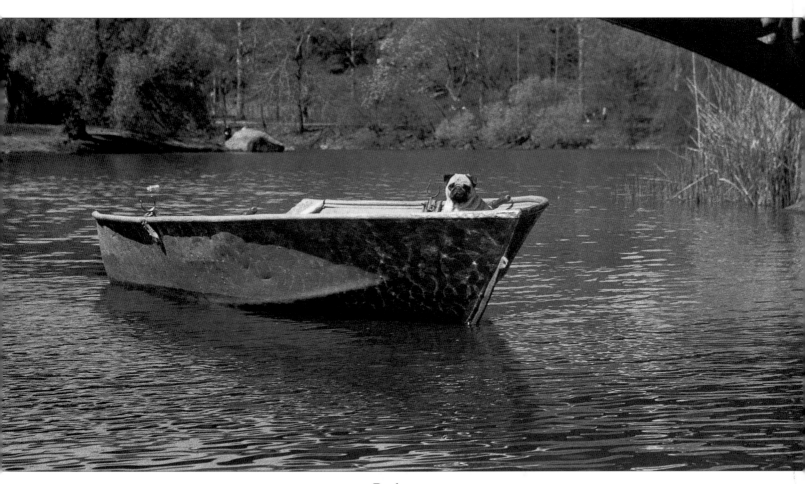

Pugboat

How much is that Puggy in the window?

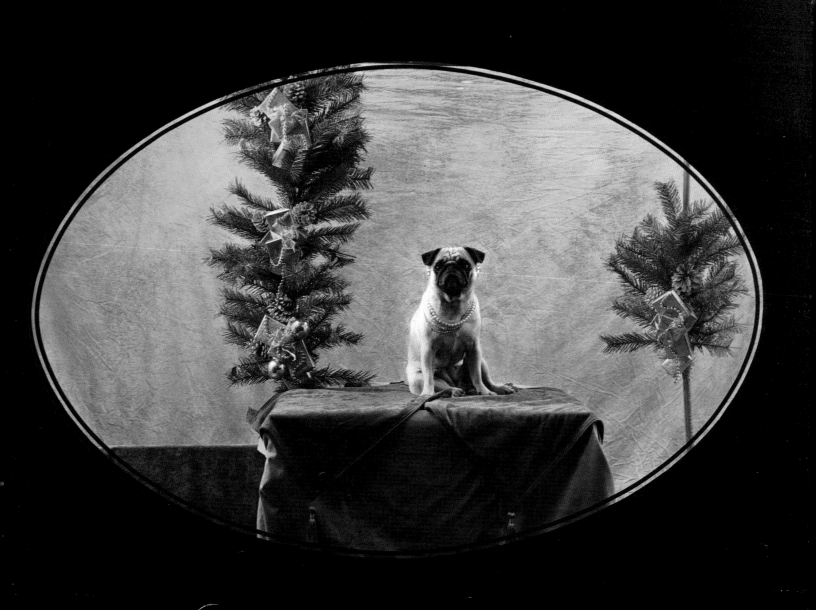

"...A boy and a dog should grow up together,
making their own mistakes and discoveries,
each molding himself to the other."

–Havilah Babcock

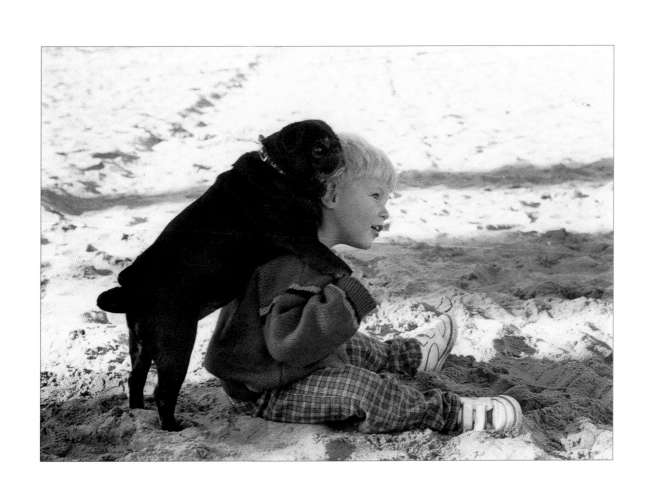

SPARK PUGS

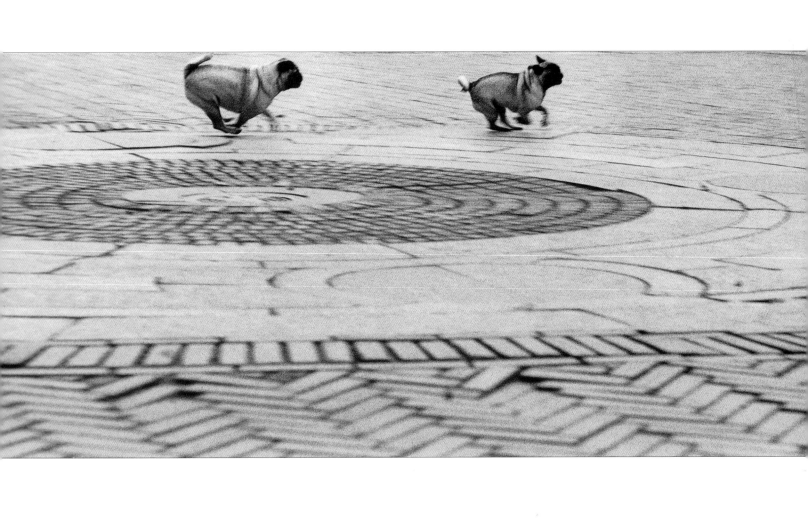

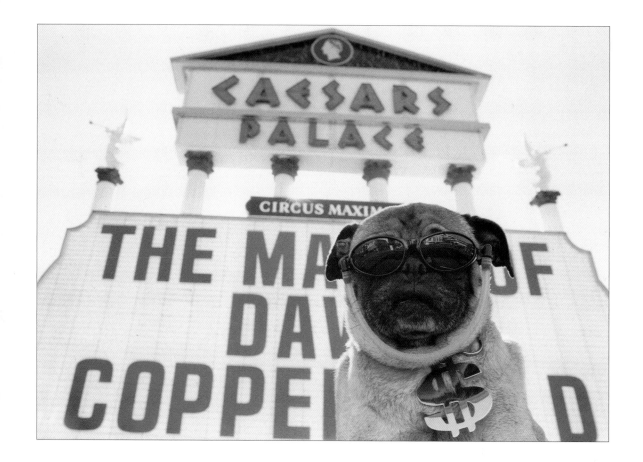

Pugs in Vegas

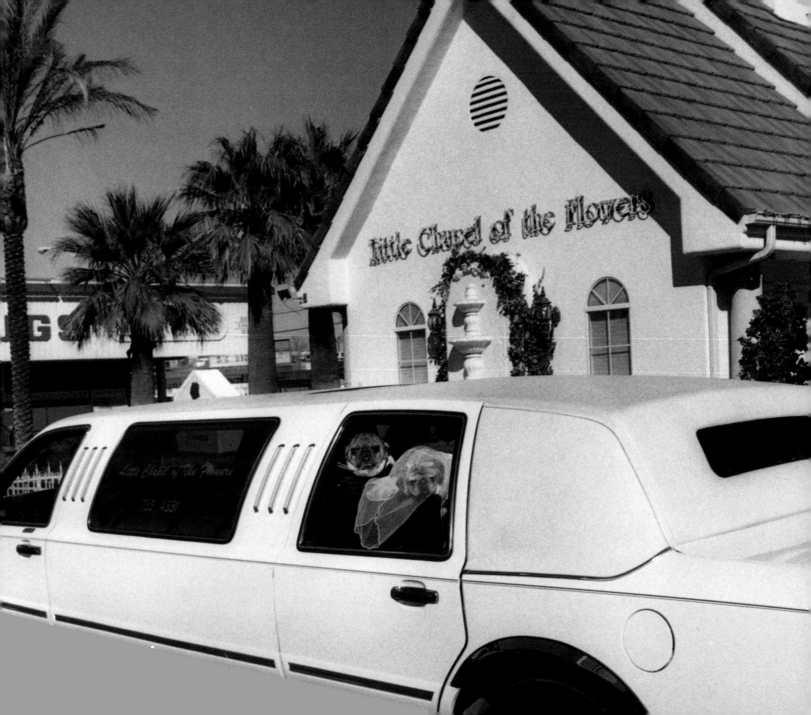

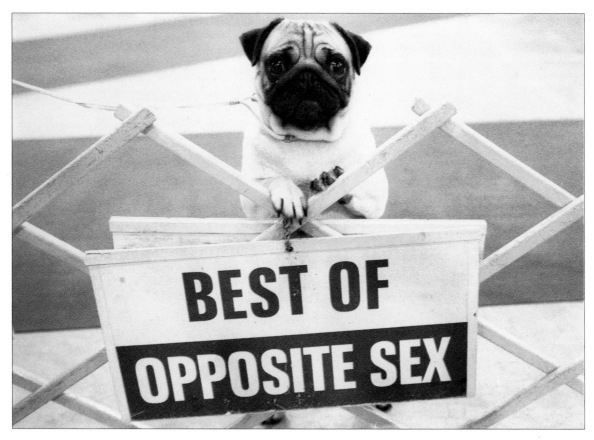

Top Dog

Pug amid the Palms

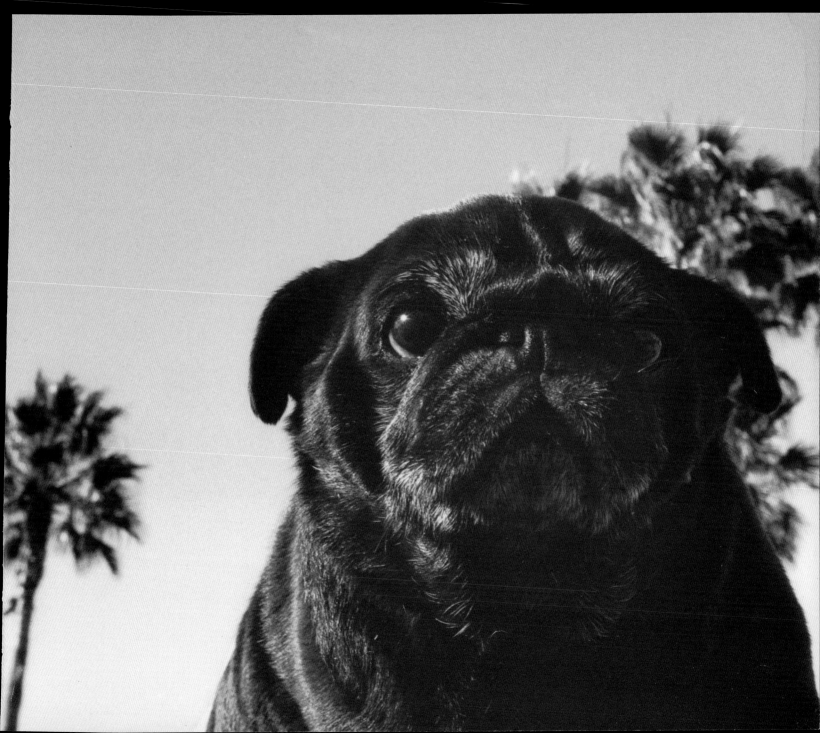

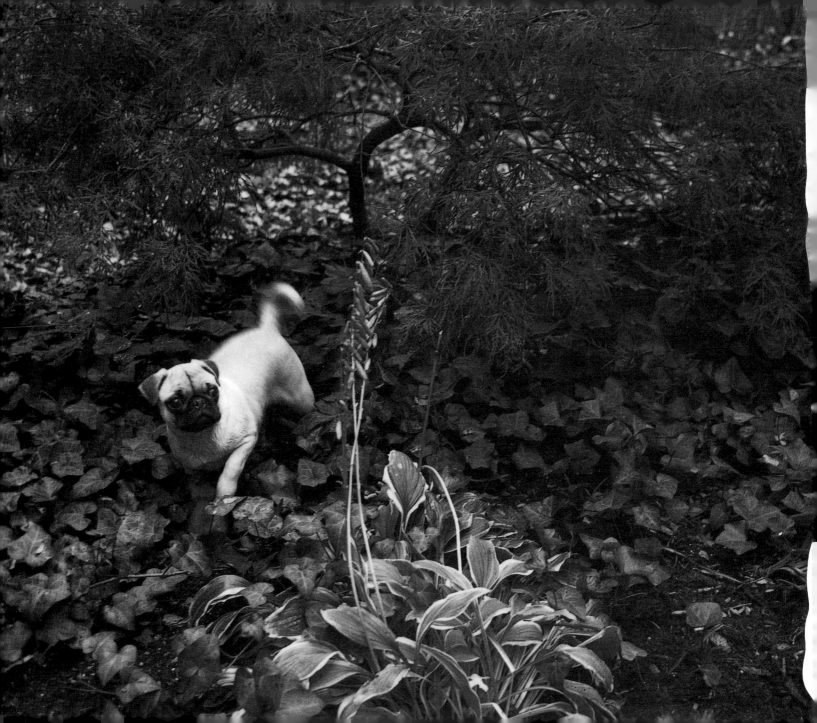

LAND ROVER

"The dog is a true philosopher."

–Socrates

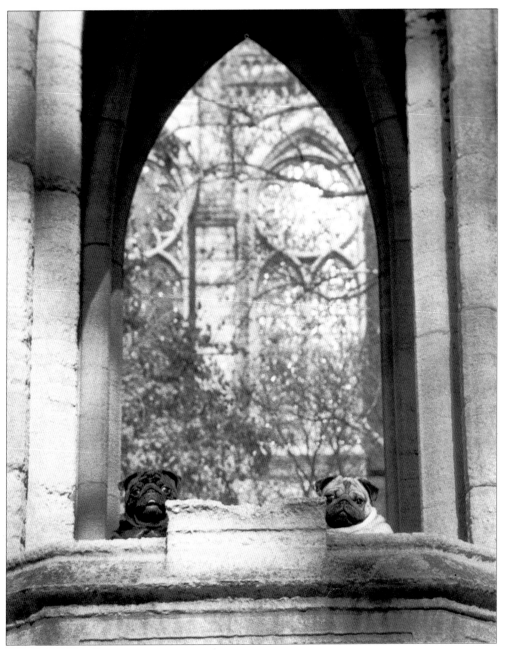

Gothic Pugs

Pug and Seek

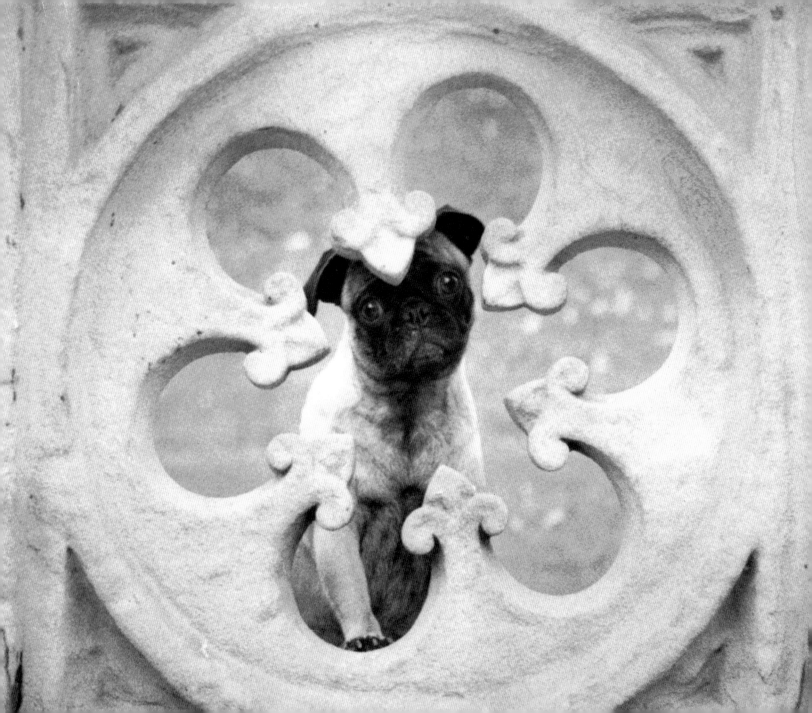

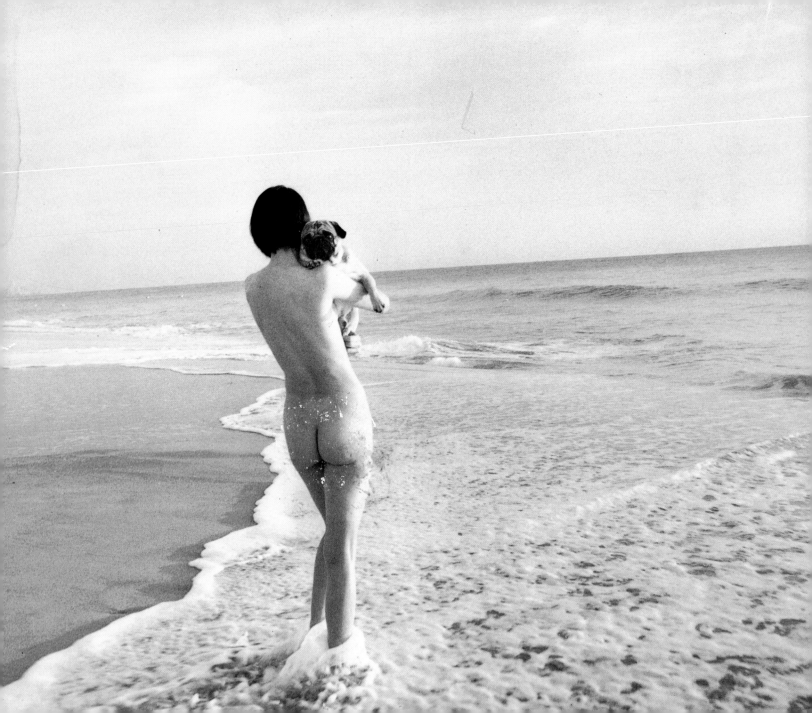

Pug 'n' Cheek

Sex, Pugs, and Rock 'n' Roll

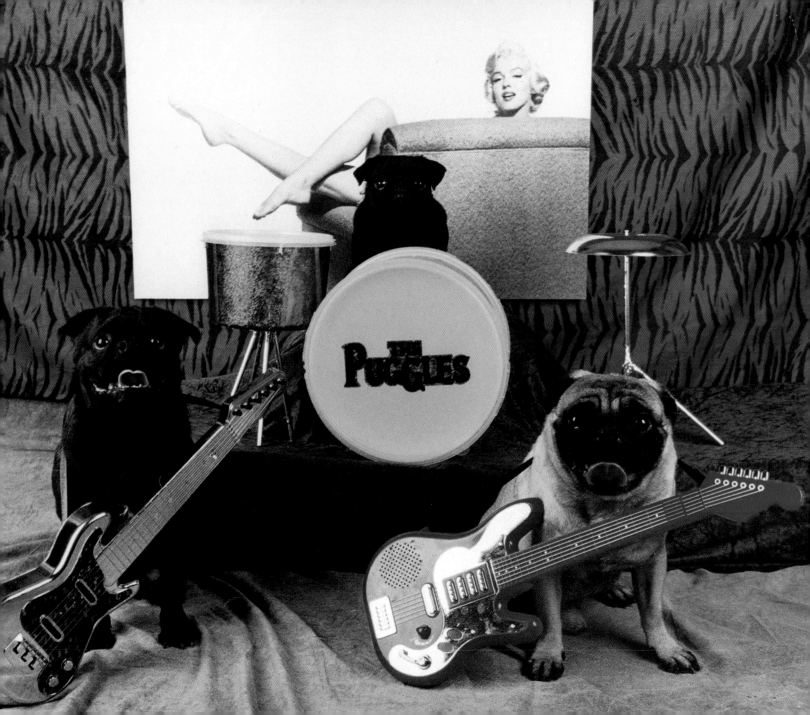

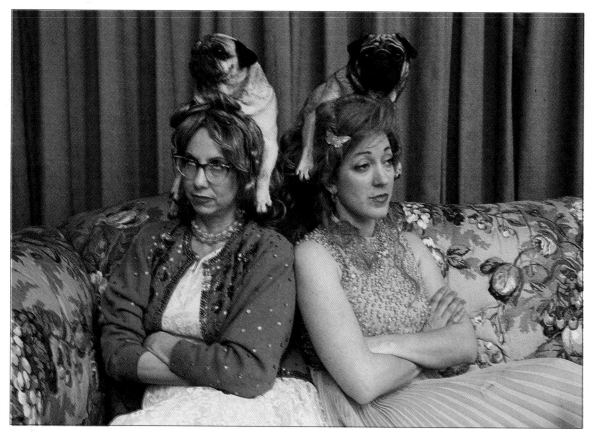

Pug-Headed

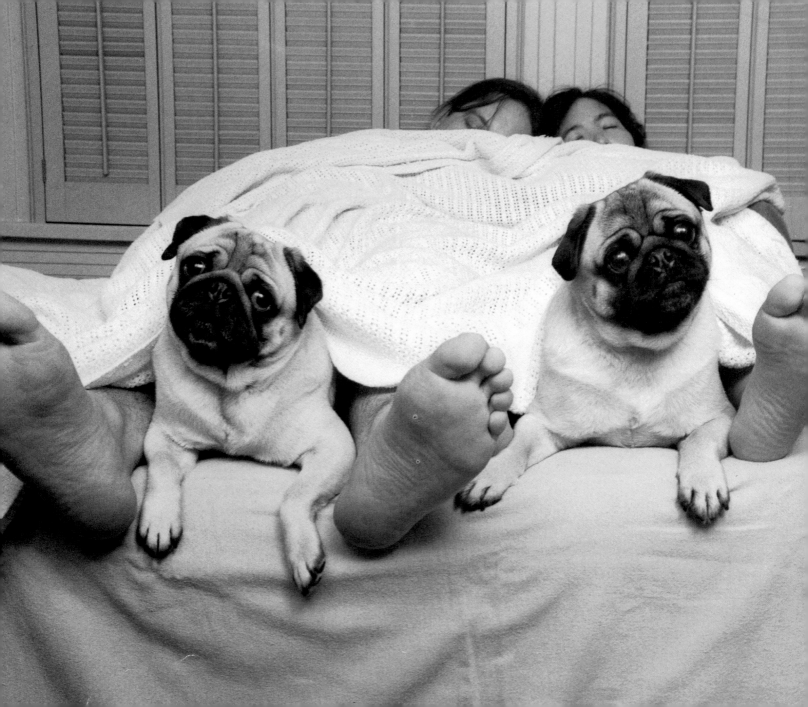

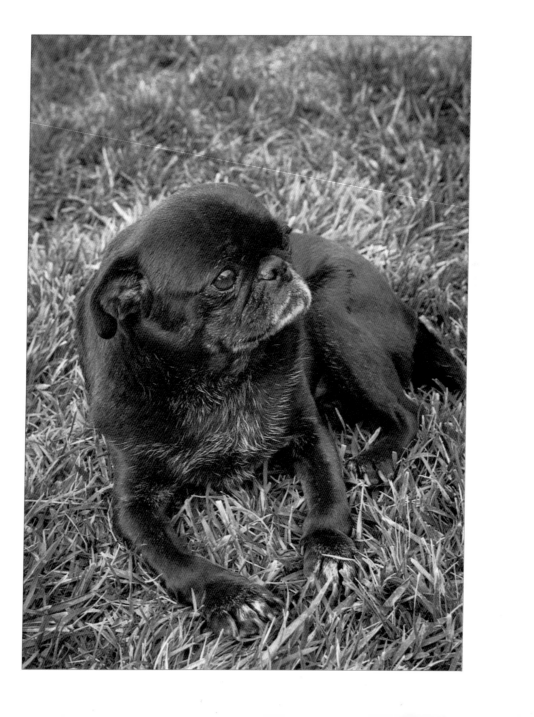

"To me, fair friend, you never can be old
For as you were when first your eyes I eyed,
Such seems your beauty still."

–William Shakespeare

Garden Pug

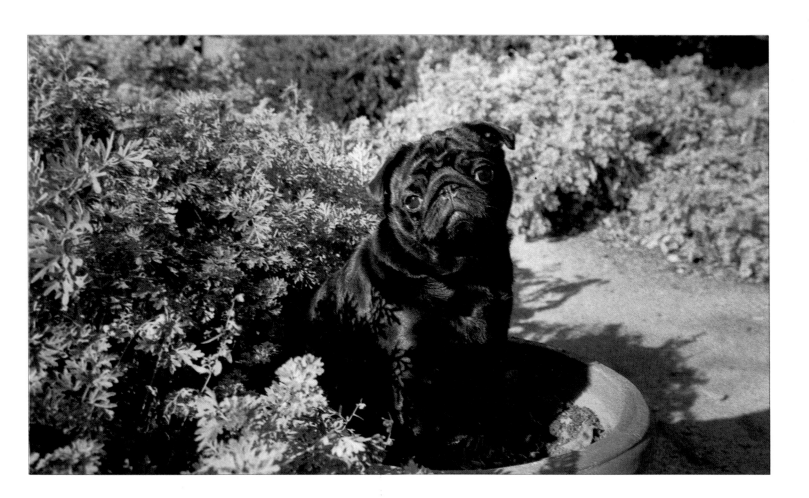

"All knowledge, the totality of all questions and answers,
is contained in the dog."

–Franz Kafka

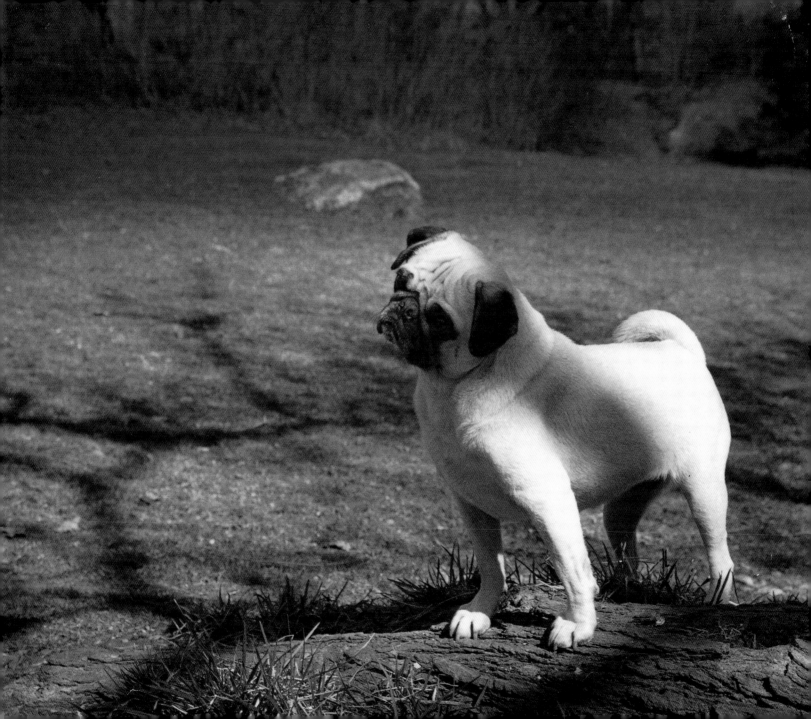

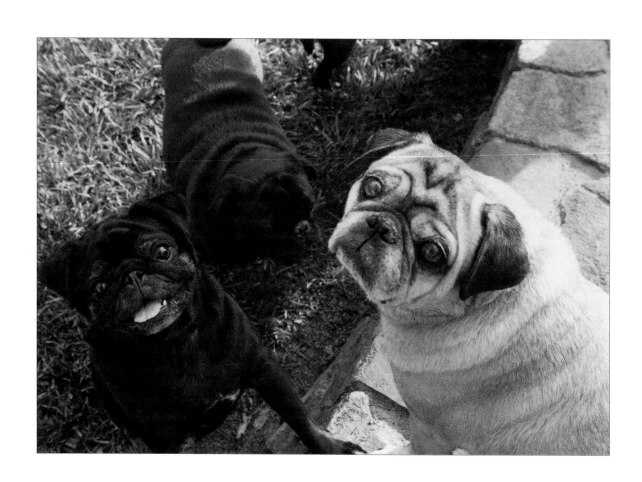

"I think the healing power of dogs
has less to do with what they give us than what
they bring out in us, with what their presence
allows us to feel and experience."

–Caroline Knapp

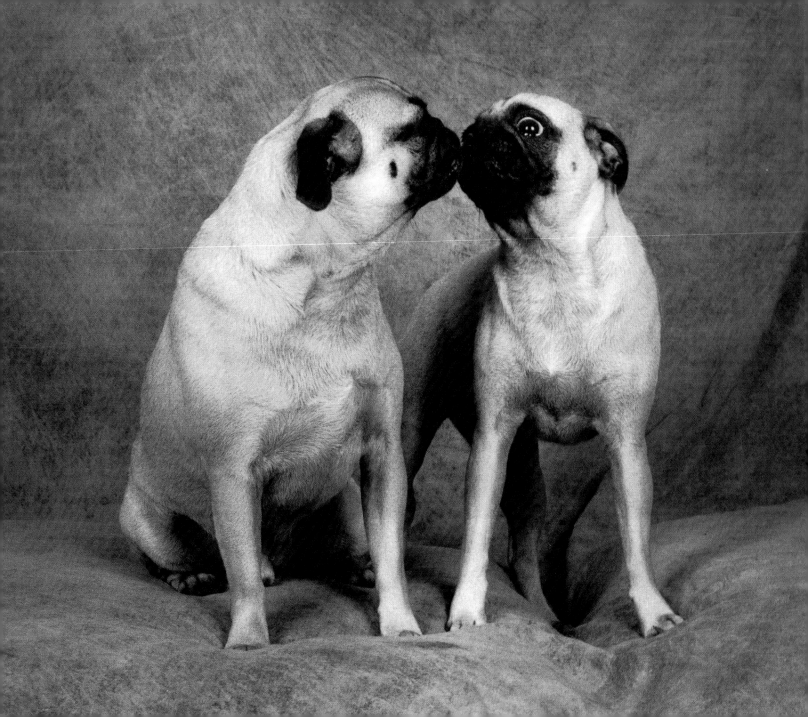

Pugs and Kisses

THE END

ACKNOWLEDGMENTS

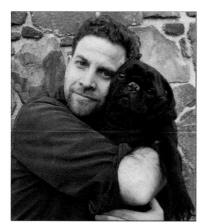

Jim Dratfield and one of *Pug Shots'*
consummate models: Teddy

A special thank-you to the following:

To Ken Clare for his technical mastery. At Viking Studio, to my editor Christopher Sweet, Francesca Belanger and Roni Axelrod. Embraces to Sherry, Sherrie and Amy and the rest of those cherished souls from Little Angels Pug Rescue, who supported this project with a gaggle of pugs and whose tenderness to pugs of all shapes and sizes is unrivaled. John Jeannopoulos for being my peerless ambassador to the pug world. Kudos to the photographic lab work of 68 Degrees and LTI and the special attention paid by Jhyda, Patty and John Fox. To the amazing Al Doggett Studios for the most brilliant touch-up and hand-tinting artistry out there. To Katherine Hammond for her unique decorative touch. Judith Wecker for her aesthetically pleasing "cheeks." Bunky for her supreme ingenuity. Clare Ferraro for her dogged enthusiasm. To Billiam Von Rostenberg's Tafia Inc.: the finest in canine apparel. To Spectra Labs and, in particular, Ed, Shalom, Lorenzo and Phil for always a job well done, and for putting up with my waltzing in just about closing time. To Shelby Marlo for tolerating the conversion of her home into Pug Central. To the talented actresses Julie Pop and Sara Ballantine for allowing pugs to go to their heads (literally). To Claudia Herbert's organizational skills and penchant for colorful stickies. To Judi Crowe, Amy Harvey and Carol Giles for their help and good humor never waning despite my wacky requests. A salute to the Armstrong Garden Center for enduring the roving pugs dodging between planters. To Jack Van Dell and Van Dell's Jewelers for allowing me usage of such valuable precious gems that caused me just the slightest of heart palpitations.

Animal Credit:

A standing ovation to the following four-legged stars of *Pug Shots:*
Franki, Clara, Chloe, Kingston, Honey, Happy, Bebe, Henri, Evvis, Eloise, Bodhi, Moses, Rifiki, Rockey, Gloria, Maggie, Scout, Harley, Banditt, Lunch, Ziggy, Cosmo, Rufus, Missy, Cindy Hugapugs Heaven Cent to Legacy, Daysee, Bruno, Lucy, Hugapug Karmel Kisses, Ch. D'Vaillant's Bandit, Ch. Hugapug Legacy in Rose, Ch. Hugapug Spend a Buck, Ch. Hugapug Jellybean, Ch. Hugapug Windjammer, Ch. Hugapug Sail Away to Coral Bay, Ch. Coral Bay's Snowdove of Hugapug, Murphy, Leonardo, Eddie, Maude, Bartholomeus, Guinevere, Maggie, Larry, Happy Donuts, Jack, Muffy, Olive, Pansy Ann, Barkley, Penelope, Pook E. Pugette, Prosperity Pie, Luigi, Teddy, Charlie, Ben, Toy, Franklin, Willy, Tigger, Puggy, Tyrone, Daisy Mae, Chaquita, Cha Cha, Opal, Ivan, Tank, Mugsey, La Toya, Smokey and Maggie Mae.